Products for a Happy Life

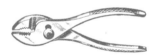

Products for a Happy Life © 2007 by Jennifer McKnight-Trontz
Design & Text: Jennifer McKnight-Trontz
Production Director: Christopher D Salyers
Editing: Buzz Poole

Every effort has been made to trace accurate ownership of copyrighted text and visual materials used in this book. Errors or omissions will be corrected in subsequent editions, provided notification is sent to the publisher.

Library of Congress Control Number: 2007930507

Printed and bound in China through Asia Pacific Offset

10 9 8 7 6 5 4 3 2 1 First edition

This edition © 2007 Mark Batty Publisher
36 West 37th Street, Penthouse
New York, NY 10018
www.markbattypublisher.com

ISBN-13: 978-09790486-3-0

Distributed outside North America by:
Thames & Hudson Ltd
181A High Holborn
London WC1V 7QX
United Kingdom
Tel: 00 44 20 7845 5000
Fax: 00 44 20 7845 5055
www.thameshudson.co.uk

Products for a Happy Life

Jennifer McKnight-Trontz

Mark Batty Publisher

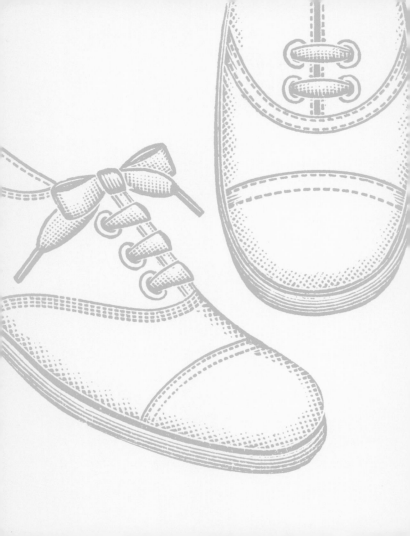

Foreword

Products for a Happy Life illustrates an ideal, simple life through the once typical—and once valued—items of the average family.

Today our aspirations run to accumulation: real estate, 401(k)s, college degrees, wealth. Everything else is simply of and for the moment, purchased with plastic, disposable and almost always made by someone overseas: clothes, furniture, televisions.

Products for a Happy Life does not aim to reject commercial society. Rather, the book seeks to untake for granted some of its simplest, most functional items: a hefty pair of scissors, a hammer with a hickory handle, a cotton T-shirt. These tangible goods, once made in factories not far from the

homes they were destined for, promise nothing more than to do their jobs.

Most of the products featured here come from merchandise catalogs of the 1910s to 1930s, some of which would make Amazon.com seem like an upstart niche boutique. From a 1930 Montgomery Ward catalog, one could buy tires; a washing machine; a sofa; and a bathroom set complete with a sink, bathtub, toilet and fixtures for $115.25.

In the same pages were items far less glamorous, but no less satisfying: a feather duster, a safety pin, a garden hose, a broom. These were not impulse purchases. In those days consumers bought more of what they needed, and less of what they wanted.

Unbothered and unswayed by excessive advertising, catalog consumers carefully read the fine print, wanting proof of quality more than false promises. Brands were rarely named. Much attention was

paid to materials and construction, like a "Good Quality Corn Broom" and a "Turkey Feather Duster."

A simple pair of skates—a "Quality Special Skating Shoe"—was intricately deconstructed: "Top grain, white elk leather, reinforced arches. Skate has extra deep drawn channel embossing for added superior strength...Trucks mounted on rubber cushions, adjustable by screw action. Heavy duty extra deep truck pivot sockets. Stamped steel trucks...Wheels equipped with adjustable threaded cones and a double row of quality precision made steel balls."

A common paring knife offered you a "quality tempered steel blade, clip pattern, finely ground, glazed polish, sharp cutting edge, hexagon shaped genuine cocobolo handle, three brass rivets."

A chair was solid oak and "sturdily constructed to withstand abuse and give many years service."

A bucket was made from "26 gauge tinplate, retinned after making. Seamless; sanitary. Heavy tinned wire bail."

The Louisville, Kentucky company that manufactured that chair and bucket, Belknap Hardware & Manufacturing, long ago shut its doors, unable to compete against particle board and plastic.

Today most of the items featured in this book are no longer made where and how they used to be. But we can still appreciate what they represent: quality, modesty, economy, durability.

For the next 120 pages, *Products for a Happy Life* will make you appreciate the well-made items you do have, stashed in your drawers, closets and cabinets, some of them so prosaic they cannot even be desired. These items will always be where you last put them, and they will not disappoint.

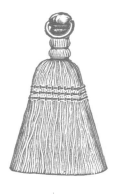

Hand Broom. Good quality corn.

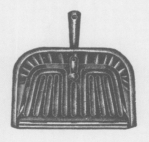

Dust Pan. Japanned steel, riveted shank.

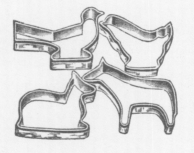

Bright Tin Animal Cookie Cutter Set.

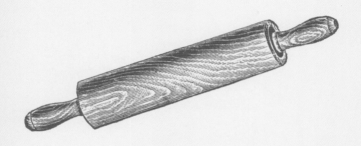

Full Size Rolling Pin. Maple, turned and sanded, revolving
handle.

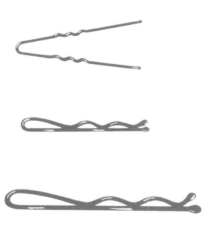

Hairpin. Bobby Pin. Roller Pin.

Black Hard Rubber Comb.

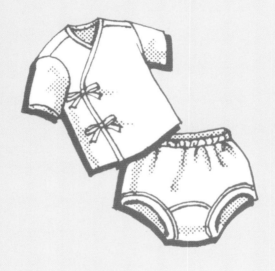

Undershirt and Training Pants. Bleached 100% cotton.

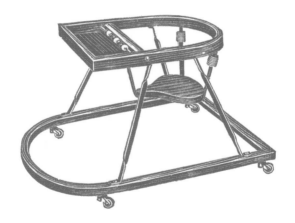

Baby Walker. Hardwood frame, seat and tray. Seat suspended on adjustable straps.

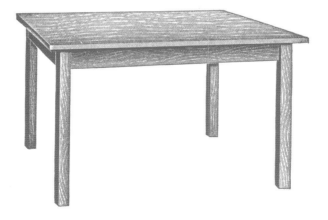

Dining Table. Gum top unfinished, sanded smoothly.

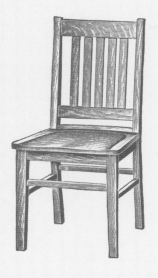

Straight Chair. Quartered oak, light finish.

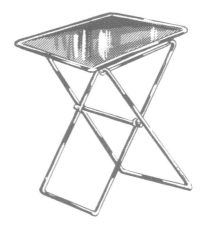

Dinner Tray. Folds up for easy storage.

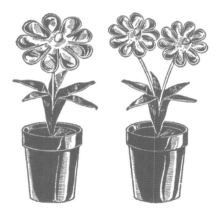

Potted Flowers. One and two blossoms to the pot.

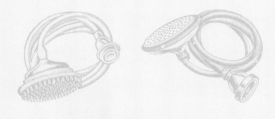

Bath and Shampoo Sprays. Five feet of heavy rubber tubing.

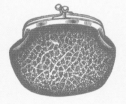
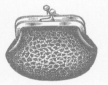

Leather Coin Purses. Black and brown calf leather.

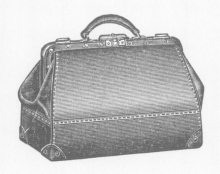

Zipper Duffel Bag. Heavy waterproof suede-like material.

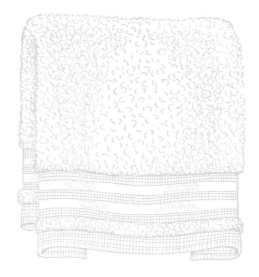

Double Terry Towel. Selected long staple cotton.

Washcloth. Solid color terry.

Barefoot Sandals. Leather, double stitched bottoms.

Baskets. Woven natural splint.

Dish Drainer. Plate rack with 14 partitions. Cutlery basket.

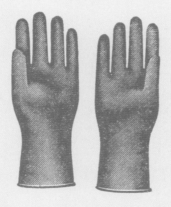

Rubber Gloves. Seamless, soft and pliable.

Glass Onyx Marbles.

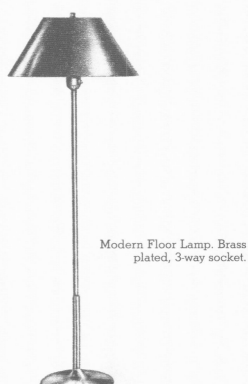

Modern Floor Lamp. Brass
plated, 3-way socket.

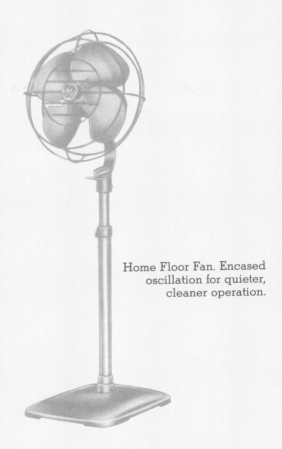

Home Floor Fan. Encased
oscillation for quieter,
cleaner operation.

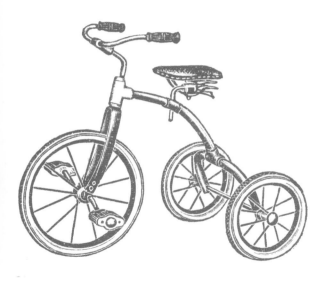

Velocipede. Tubular, frame, riveted spokes. Ball bearing
front wheel, rubber pedals and grips, coil spring saddle.

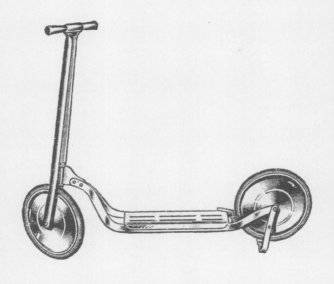

Scooter. Flat steel frame; stamped steel foot board. Varnished
hardwood grip.

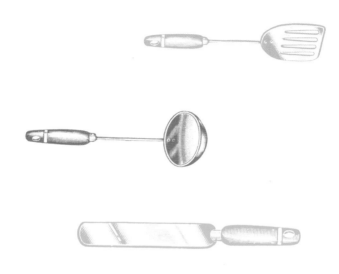

Kitchen Tools. Metal parts bright, polished nickel plated.
Hardwood hang-up handles, enameled with white band.

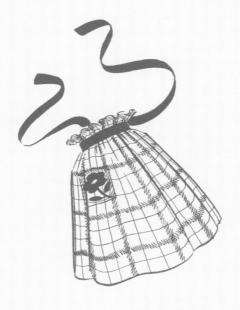

Cotton Apron. Ties at waist.

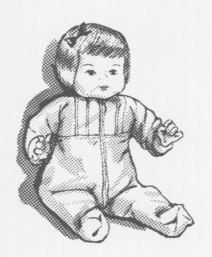

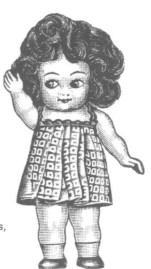

Dolls. Flesh-tinted, jointed arms,
painted features, mohair wig.

Sponge Rubber Balls. Rainbow enameled color combinations.

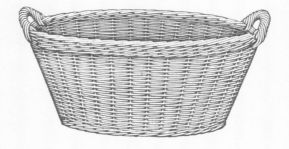

Whole Willow Clothes Basket. Strong handles and bottom.

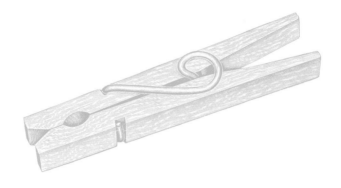

Spring Clothes Pin. Good quality wood. Strong bright wire
side coil spring, will not twist apart.

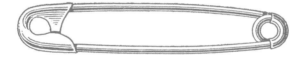

Safety Pin. Tempered nickeled steel.

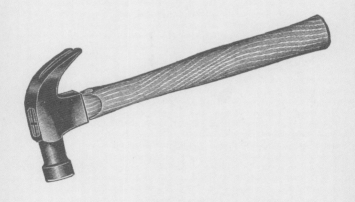

16 oz. Drop Forged Steel Hammer. Bell face, first quality shaped and waxed hickory handle.

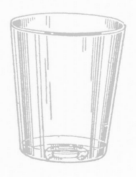

Drinking Glass. Horseshoe bottom. Crystal, fire polished.

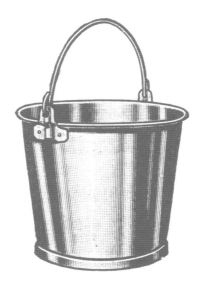

Seamless Pail. Made from 26 gauge tinplate, retinned after making. Sanitary. Heavy tinned wire bail.

Bicycle.
Sturdily constructed, appeals to all who see it. Beautifully
finished in brilliant red enamel and striped in black and
white.

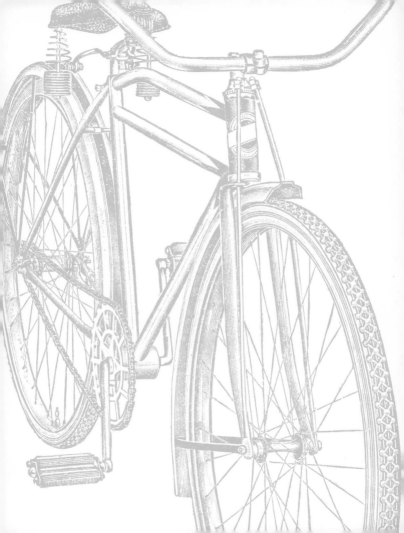

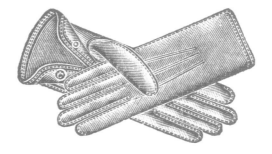

Suede Gloves. Light weight, soft finish, seamless back;
English thumb, outseam quirked fingers, snap button.

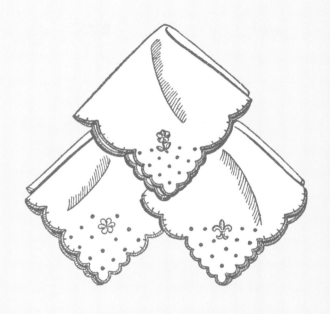

Women's Embroidered Lawn Handkerchiefs. Scalloped edges.

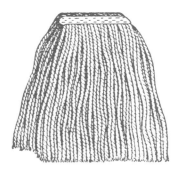

Durable Mop Head. 4-ply twisted white cotton yarn,
absorbent, cut ends, taped top, good wearing quality.

Mop Holder. Stamped steel head and lever, heavy coil spring.

Husband Pillow.

Club Chair. Plain flounce with inverted pleats at corners.

Women's Underwear. Fun prints and colors.

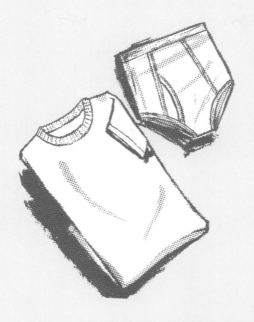

Men's Undershirt and Briefs. 100% cotton.

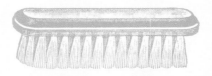

Nail Brush. Genuine bleached white bristles, heavy celluloid back with colored imitation sea pearl overlay.

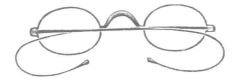

Spectacles. Solid nickel. Has interchangeable screw, well finished and durable.

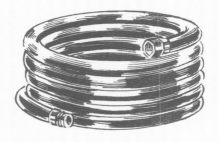

Garden Hose. Seamless molded rubber inner tube, and
extra heavy black rubber covering.

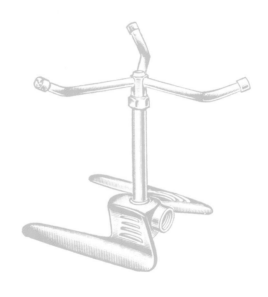

Lawn Sprinkler. Graceful and functional base, brass head
with plenty of threads; polished brass arms.

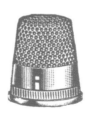

Thimble. Plated brass.

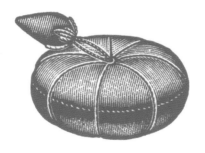

Tomato Pin Cushion. Red cloth covered.

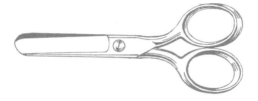

Round Point Scissors. Fully nickel plated, steel rivet.

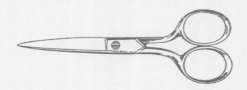

Sharp Point Scissors. Nickel plated, steel rivet.

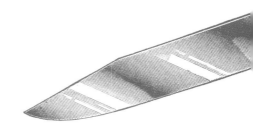

Paring Knife. Quality tempered steel blade.

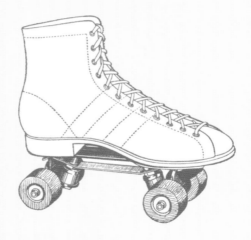

Quality Special Skating Shoe. Top grain white elk leather.

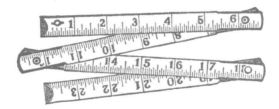

Zig-Zag Rule. Riveted spring joints. Flexible hardwood; stiff
spring in joints holds rule rigid when open.

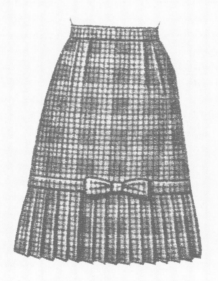

Plaid Skirt. Chic little skirt in a pretty, tile-patterned print.
Pleated flounce is banded and bowed to match.

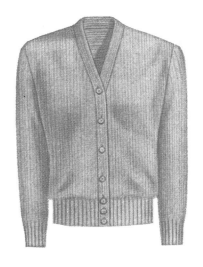

Cardigan. Dyed to match buttons.

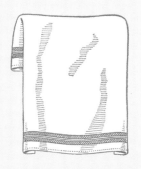

Kitchen Towels. Part linen, fast color.

Pocketbook. Genuine leather lined.

Pocket Knife. Highly polished steel blades.

Wrapping Twine. Fine India hemp, smooth polished finish.

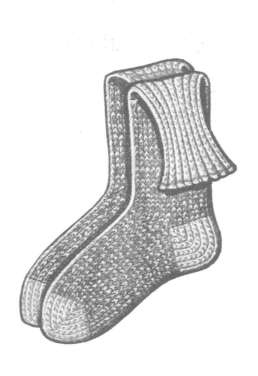

Seamless Toe Sock. Made of clean yarn, not shoddy.

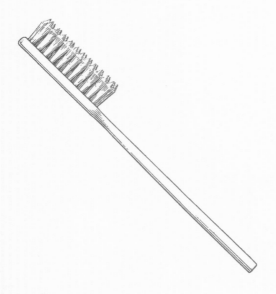

Toothbrush. Accurately trimmed bristles.

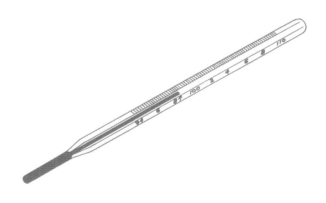

Oral Thermometer. Figures in black. Very easy to read.

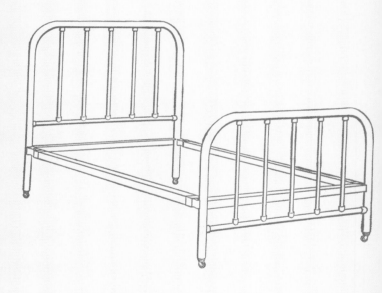

Post Iron Bed. All white enamel finish. With casters.

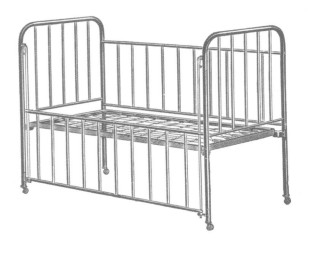

Steel Crib. All white enamel finish. With casters.

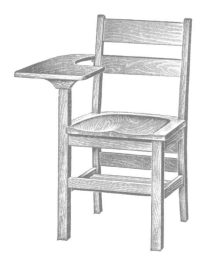

Tablet Arm Chair. Solid oak constructed to withstand abuse.

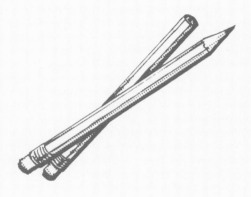

Pencils. Cedar wood with eraser.

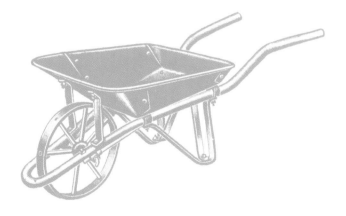

Wheelbarrow. Extra heavy all steel construction.

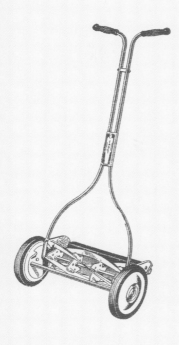

Hand Mower. Precision ground special alloy blades.

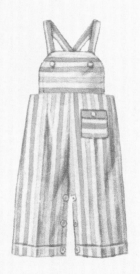

Striped Crawler. Firmly woven cotton and rayon poplin with
six-gripper crotch, cuffed legs, elastic in waistback.

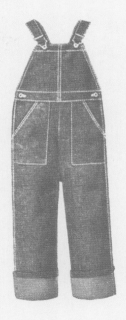

Denim Overall. Sanforized navy blue denim, won't shrink.

Light Bulb.

Step Ladder. Knot-free spruce.

Sanitary Weave Dish Cloth. Easy to keep clean.

Dinner; Lunch; Dessert or Salad; Bread and Butter Plates.

Black Japanned Wire Hanger. 12-gauge wire. Hardwood
Hanger. Round, smooth finish, coppered hook.

Denim Jacket. Fitted style, won't shrink.

Diaper Covers. Heavy weight, ventilated sides, sewed ruffled waistband and leg openings.

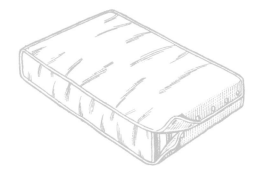

Mattress Cover. Superior quality heavy weight cloth, rubber
buttons. Taped seams.

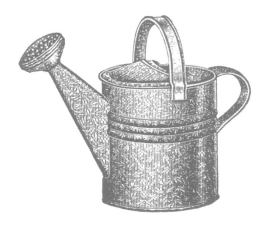

Watering Can. Galvanized steel, aluminum finish.

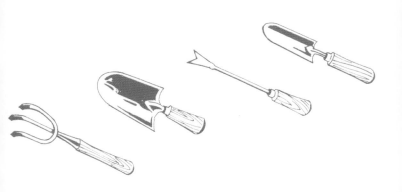

Garden Tools Set. Wood handles.

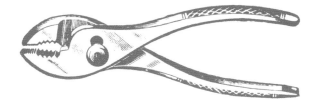

Slip Joint Pliers. Forged steel, hardened.

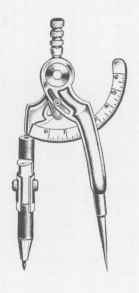

Pencil Compass. Nickeled finish, with measuring arc.

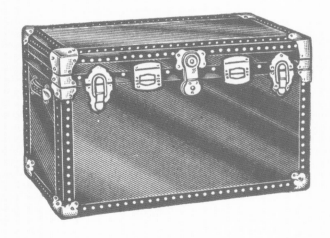

Dress Trunk. Round edges, brass plated steel hardware.

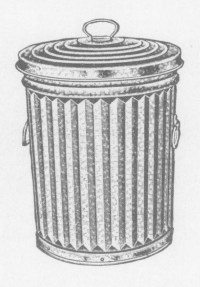

Galvanized Garbage Can. Deep corrugations.

Colored Novelty Rattles.

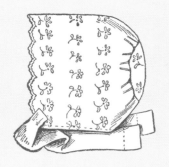

Infant's Cap. Embroidery, scalloped edge.

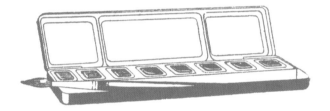

Water Colors. Eight half pans of semi-moist colors. Enameled box; No. 7 camel's hair brush.

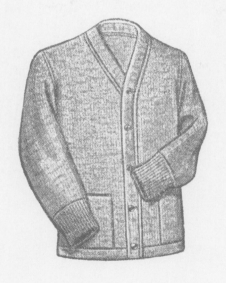

Wool Flat Knit. Five buttons, ribbed cuffs, hemmed bottom.

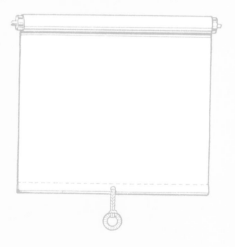

Cloth Window Shade.

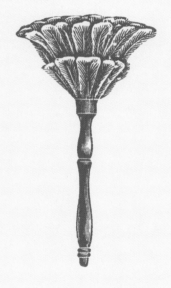

Turkey Feather Duster. Enamel handle.

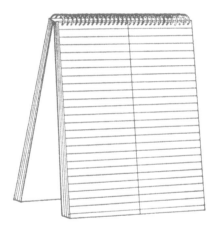

Steno Book. Lies flat and turns easily for speedy notes.

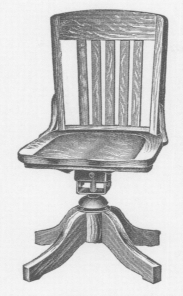

Revolving Office Chair. Solid oak.

Pennant Baseball Bat. Hardwood, sanded and tumbled.

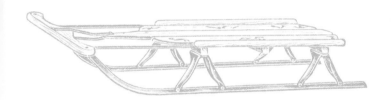

Steering Sled. Grooved runners, steel front.

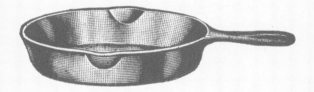

Cast Iron Skillet. Ground and polished.

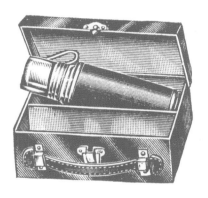

Lunch Box. With Thermos bottle. Heavy tin case.

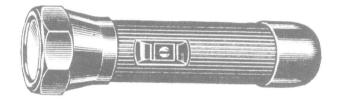

Flashlight. Heavy duty industrial, fully insulated.

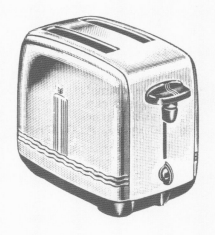

Electric Toaster. Solid sturdy steel construction, finished in lustrous mirror chromium. Toast automatically pops up, ready to serve.

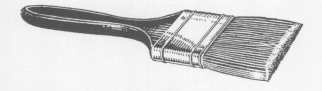

Varnish Brush. Mixed black goat hair, varnished handles.

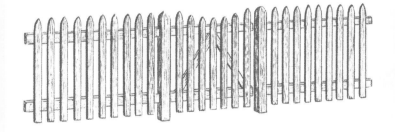

Picket Fence. Planed smooth on all sides. Ready for painting.

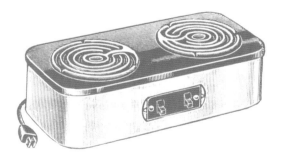

Electric Hot Plate. Two Burner, black top, single heat open type units. Heavy duty double pole toggle switches.

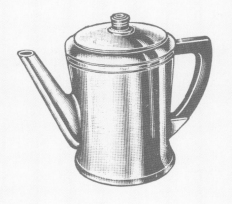

Aluminum Percolator. Deep flange cover, full-view glass top.

Credits

Rubber sole shoes from Baltimore Bargain House, 1917. Shirt from Baltimore Bargain House 1917. Scissors from Butler Brothers, 1931. Hand broom from Butler Brothers, 1931. Dust pan from Butler Brothers, 1931. Cookie cutter set from Butler Brothers, 1931. Rolling pin from Butler Brothers, 1931. Hairpin, bobby pin, roller pin from Standard Textbook of Cosmetology by Mary Healy, Milady Publishing Corporation, 1938, 1985. Comb from Standard Textbook of Cosmetology by Mary Healy, Milady Publishing Corporation, 1938, 1985. Undershirt and training pants from Metro Associated Services, Inc., 1961. Baby walker from Belknap Hardware & Manufacturing Co., 1932. Dining table from Belknap Hardware & Manufacturing Co., 1932. Chair from Belknap Hardware & Manufacturing Co., 1932. Dinner tray from Clip art service, 1952. Potted flowers from Butler Brothers, 1931. Bath sprays from Montgomery Ward & Co, 1930. Coin purse from Butler Brothers, 1931. Duffel bag from Baltimore Bargain House, 1917. Towel from Butler Brothers, 1931. Washcloth from Butler Brothers, 1931. Sandals from Baltimore Bargain House, 1917. Baskets from Butler Brothers, 1931. Dish drainer from Butler Brothers, 1931. Rubber gloves from Belknap Hardware & Manufacturing Co., 1932. Marbles from Butler Brothers, 1931. Floor lamp from Sears Roebuck and Co., 1953. Fan from General Electric Company, no date. Tricycle from Belknap Hardware & Manufacturing Co., 1932. Scooter from Belknap Hardware & Manufacturing Co., 1932. Kitchen Tools from Belknap Hardware & Manufacturing Co., 1950. Apron from Young Folks at Home by Florence La Ganke Harris and Treva E. Kauffman, D. C. Heath and Company, 1953. Doll from Metro Associated Services, Inc., 1961. Doll from Butler Brothers, 1931. Balls from Butler Brothers, 1931. Clothes basket from Butler Brothers, 1931. Clothes pin from Butler Brothers, 1931. Safety pin from Butler Brothers, 1931. Hammer from Butler Brothers, 1931. Drinking glass from Butler

Brothers, 1931. Pail from Belknap Hardware & Manufacturing Co., 1950. Bicycle from Belknap Hardware & Manufacturing Co., 1932. Gloves from Baltimore Bargain House, 1917. Handkerchiefs from Butler Brothers, 1931. Mop from Butler Brothers, 1931. Husband from Metro Associated Services, Inc., 1968. Club chair from Singer Sewing Book by Mary Brooks Picken, Singer Sewing Machine Company, 1953. Ladies underwear from Metro Associated Services, Inc., 1969. Men's underwear from Metro Associated Services, Inc., 1969. Nail brush from Butler Brothers, 1931. Spectacles from Baltimore Bargain House, 1917. Garden hose from Clip Art Services, 1952. Lawn sprinkler from Belknap Hardware & Manufacturing Co., 1950. Thimble from Butler Brothers, 1933. Pin cushion from Butler Brothers, 1933. Scissors from Practical Drawing Company, 1923. Paring knife from Butler Brothers, 1931. Skate from Belknap Hardware & Manufacturing Co., 1950. Zig-Zag rule from Belknap Hardware & Manufacturing, 1932. Skirt from Walter Field Co., 1960. Sweater from Sears Roebuck and Co., 1953. Kitchen towels from Butler Brothers, 1933. Pocketbook from Sears Roebuck and Co., 1953. Pocket knife from Baltimore Bargain House, 1917. Twine from Belknap Hardware & Manufacturing Co., 1950. Socks from Butler Brothers, 1933. Toothbrush from Health and Success by J. Mace Andress and W. A. Evans, Ginn and Company, 1925. Thermometer from Doctors Health Guide by James Fox Rogers, M.D., Physicians Mutual Insurance Company, no date. Iron bed from Baltimore Bargain House, 1917. Crib from Belknap Hardware & Manufacturing Co., 1932. Tablet arm chair from Belknap Hardware & Manufacturing Co., 1932. Pencils from Metro Associated Services, Inc., 1967. Wheelbarrow from Sears Roebuck and Co., 1953. Lawn mower from National-Porges Co., 1953. Crawler from Walter Field Co., 1960. Overalls from Sears Roebuck and Co., 1953. Light bulb from Home Mechanics for

Girls by J. C. Woodin, The McCormick-Mathers Company, 1938. Step ladder from Home Painting, Wallpapering and Decorating, Wm. H. Wise & Co., Inc., 1951. Dish cloth from Butler Brothers, 1933. Plates from Your Home and You by Carlotta C. Greer, Allyn and Bacon, 1947. Clothes hangers from Butler Brothers, 1931. Jean jacket from Sears Roebuck & Co., 1932. Diaper covers from Butler Brothers, 1931. Mattress cover from Butler Brothers, 1933. Watering can from Butler Brothers, 1931. Garden tools from Metro Associated Services, Inc., 1969. Pliers from Belknap Hardware & Manufacturing Co., 1950. Compass from Belknap Hardware & Manufacturing Co., 1950. Trunk from Butler Brothers, 1933. Garbage can from Belknap Hardware & Manufacturing Co., 1950. Rattles from Montgomery Ward & Co., 1930. Bonnet from Baltimore Bargain House, 1917. Watercolors from Practical Drawing Company, 1923. Sweater from Butler Brothers, 1933. Window shade from Belknap Hardware & Manufacturing Co., 1950. Feather duster from Butler Brothers, 1931. Notebook from Belknap Hardware & Manufacturing Co., 1950. Office chair from Belknap Hardware & Manufacturing Co., 1932. Baseball bat from Butler Brothers, 1931. Sled from Belknap Hardware & Manufacturing Co., 1932. Skillet, Butler Brothers, 1931. Lunchbox from Butler Brothers, 1931. Flashlight from Belknap Hardware & Manufacturing Co., 1950. Toaster from Belknap Hardware & Manufacturing Co., 1950. Picket fence from Sears Roebuck and Co., 1953. Lacquer brush from Butler Brothers, 1931. Hot plate from Belknap Hardware & Manufacturing Co., 1950. Percolator from Belknap Hardware & Manufacturing Co., 1950. Handkerchief from Butler Brothers, 1933. Scissors from Practical Drawing Company, 1923. Endpapers: bed spring from Belknap Hardware & Manufacturing Co., 1932.